DRAW YOUR OWN MANGA

Blank Comic Book

TUTTLE Publishing

Tokyo | Rutland, Vermont | Singapore

HOW TO USE THIS BOOK

The panels and templates are already laid out for you . . . so are you ready to create your own comics, make your own manga?

A quick comic or a longer story playing out over many pages or volumes? We've got you covered! Fill in the blanks to tell your story as only you can!

Start with the basics and build your world from there: character creation, poses and panels—and don't forget the speech balloons.

Remember there are no rules. No training or classes are required. Artists of all levels can create memorable characters and dynamic, page-turning stories. All you need is a free hand and a free imagination.

Fill in the frames as your story emerges before your eyes. Let your characters and your creativity soar!

Design Your Own Cover

Cover Template

Page Template

DRAWING A MANGA FACE

Let's start with one of your character's most important parts: the face! Follow these four steps to give your creation features and an expression.

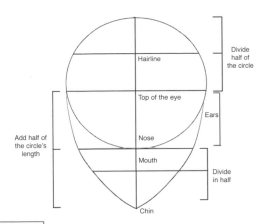

STEP 1

Outline the skull and jaw. The crisscrossing lines in the center help you place the nose and eyes.

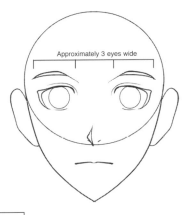

STEP 2

The mouth is added to the bottom of the skull circle. The bottom of the eyelid touches the eye line.

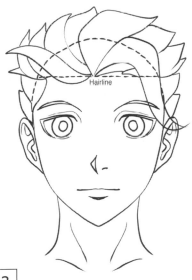

STEP 3

A simple line can indicate the nose. The hair adds size and volume to the head.

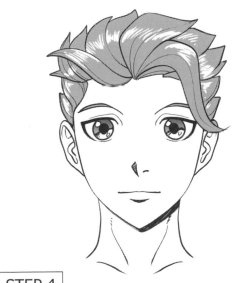

STEP 4

Now add details and finishing touches: shadows, highlights and strands of hair.

PRO TIPS

The nose is about halfway between the bottom of the chin and the eye line. The distance between the eyes is about the width of a single eye.

COMMON FACIAL EXPRESSIONS

Expressions tell your readers exactly how your characters are feeling. A clear and easy-to-understand expression helps convey emotion and advance your story as well.

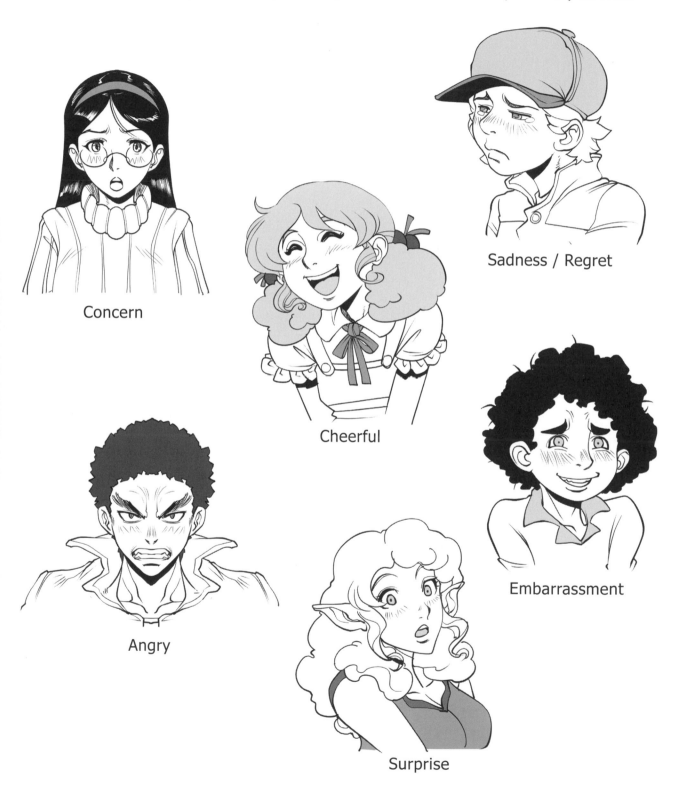

Concern

Cheerful

Sadness / Regret

Angry

Surprise

Embarrassment

CREATING CHARACTERS

Follow these four steps to create a funny or fabulous furry. Or any character you like.
A simple sketch soon turns into a fully fleshed manga character!

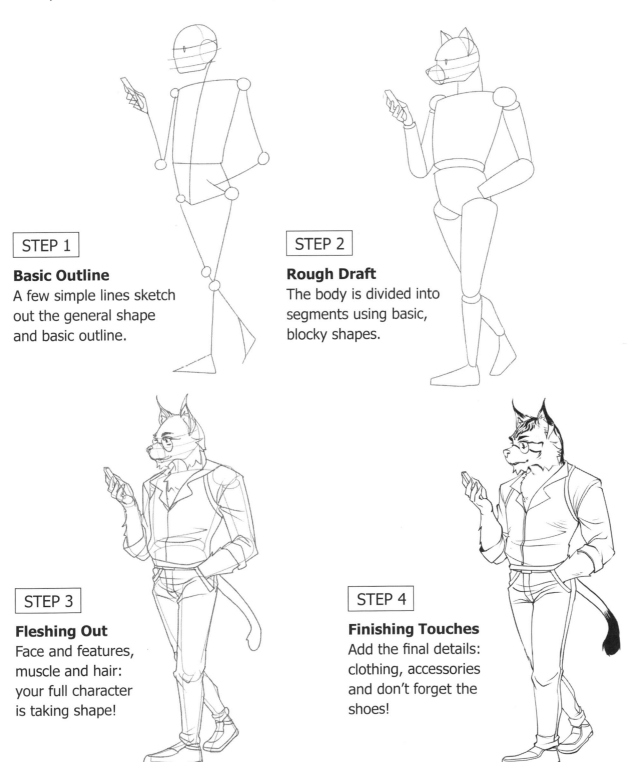

STEP 1

Basic Outline
A few simple lines sketch
out the general shape
and basic outline.

STEP 2

Rough Draft
The body is divided into
segments using basic,
blocky shapes.

STEP 3

Fleshing Out
Face and features,
muscle and hair:
your full character
is taking shape!

STEP 4

Finishing Touches
Add the final details:
clothing, accessories
and don't forget the
shoes!

POWERFUL POSES & AMAZING ACTION

Set your characters in motion. The proper pose captures your reader's attention and adds visual variety to your story.

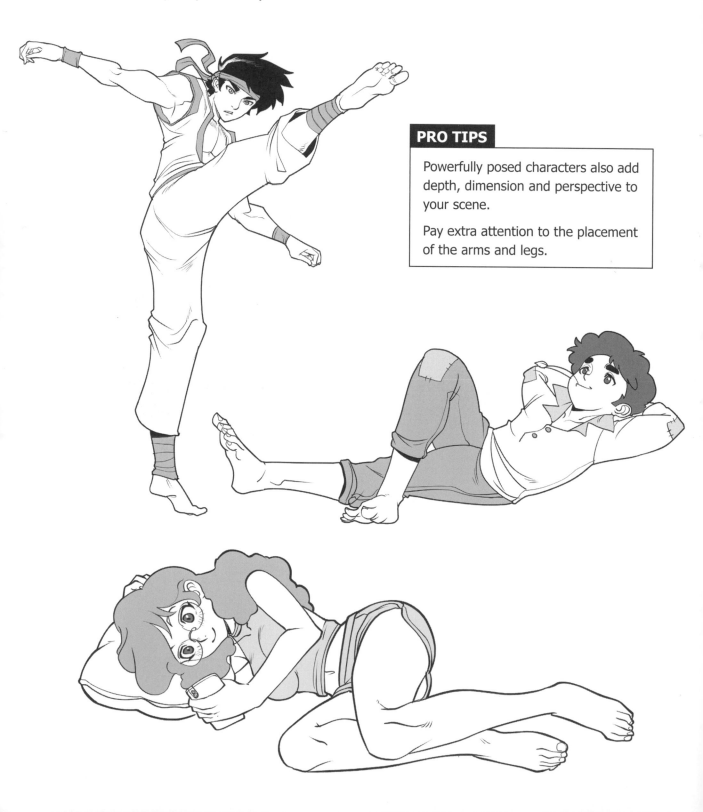

PRO TIPS

Powerfully posed characters also add depth, dimension and perspective to your scene.

Pay extra attention to the placement of the arms and legs.

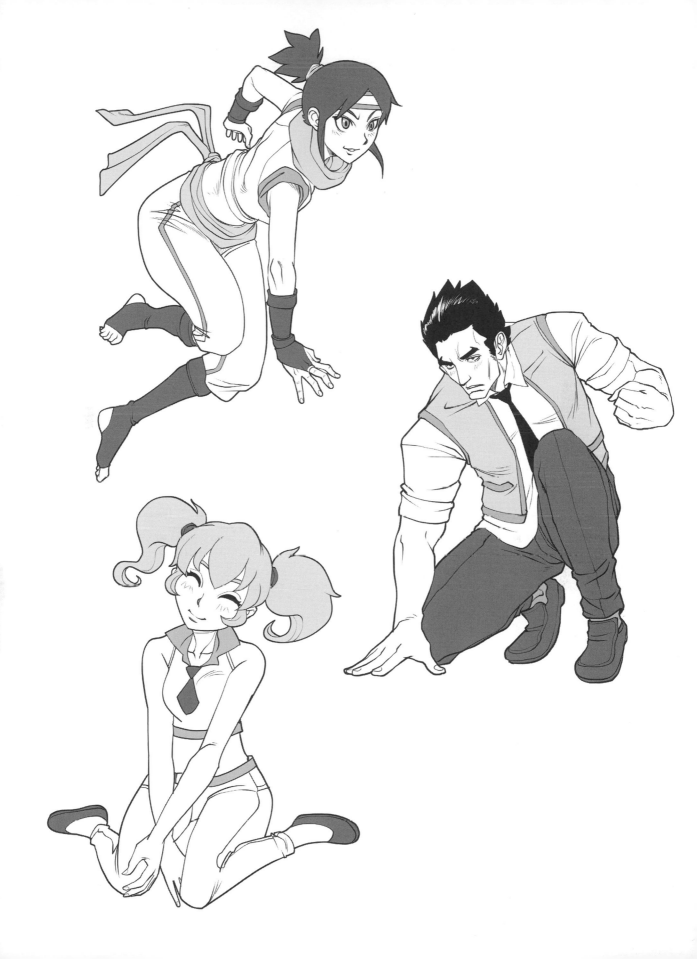

ANGLES & PERSPECTIVES

One way to tell your story is to start with a wide-angle view, an establishing shot. Then move your viewer closer to the action, panel by panel, ending on a close-up.

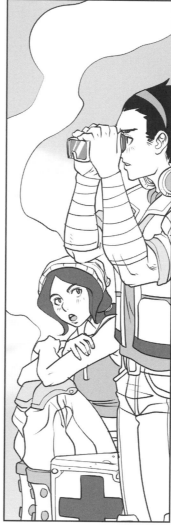

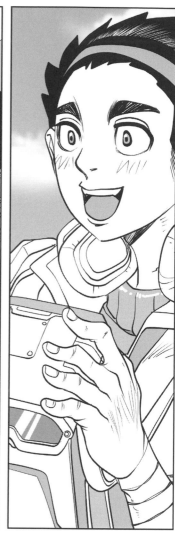

Establish the Scene
A wide-angle view helps set the scene. Where are we and what's going on? This angle makes that clear.

Zoom In
This is sometimes called a medium shot. The viewer is closer to the action, but not too close.

Close-Up
In your face! Great for intense or emotional scenes. Or when you want to draw your reader directly into the action.

TELLING YOUR STORY

Panels progress in the same way characters are created. The same four steps apply. Start simple, adding details as you go. Your story's taking shape before your eyes!

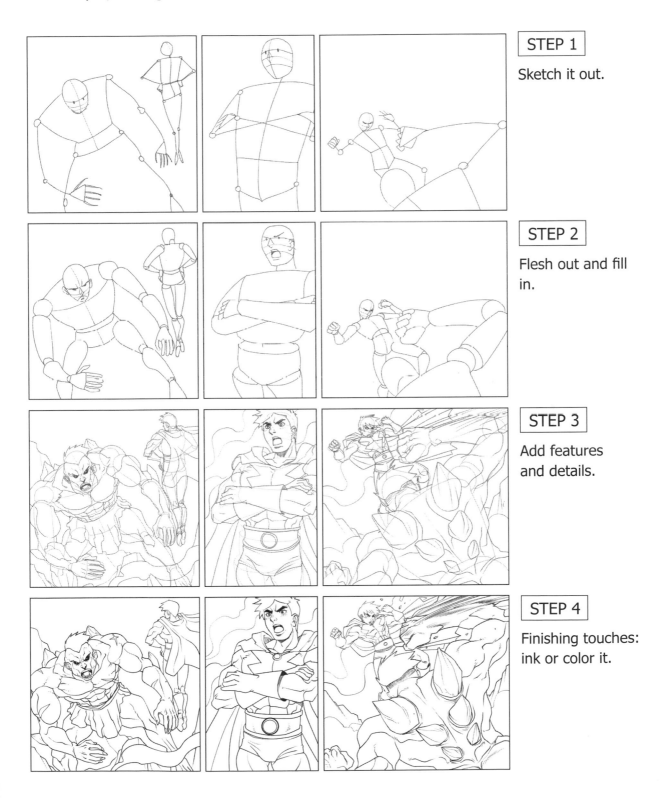

STEP 1

Sketch it out.

STEP 2

Flesh out and fill in.

STEP 3

Add features and details.

STEP 4

Finishing touches: ink or color it.

FLEXIBLE SPEECH AND THOUGHT BALLOONS

Here are some common balloons and text boxes. Cut them out, then place and trace them. Or design your own. Create the shape that's needed to fit your characters' words. Just make sure they read left to right, top to bottom.

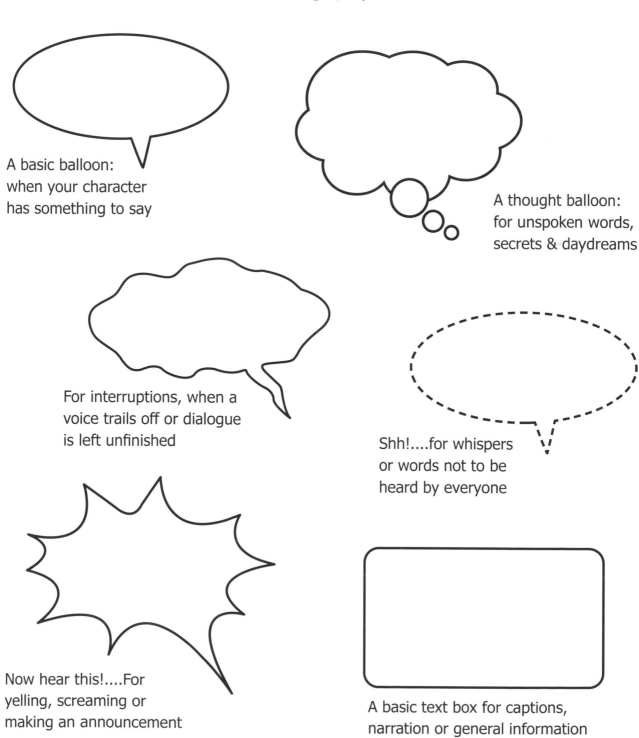

A basic balloon: when your character has something to say

A thought balloon: for unspoken words, secrets & daydreams

For interruptions, when a voice trails off or dialogue is left unfinished

Shh!....for whispers or words not to be heard by everyone

Now hear this!....For yelling, screaming or making an announcement

A basic text box for captions, narration or general information

Design Your Own Cover

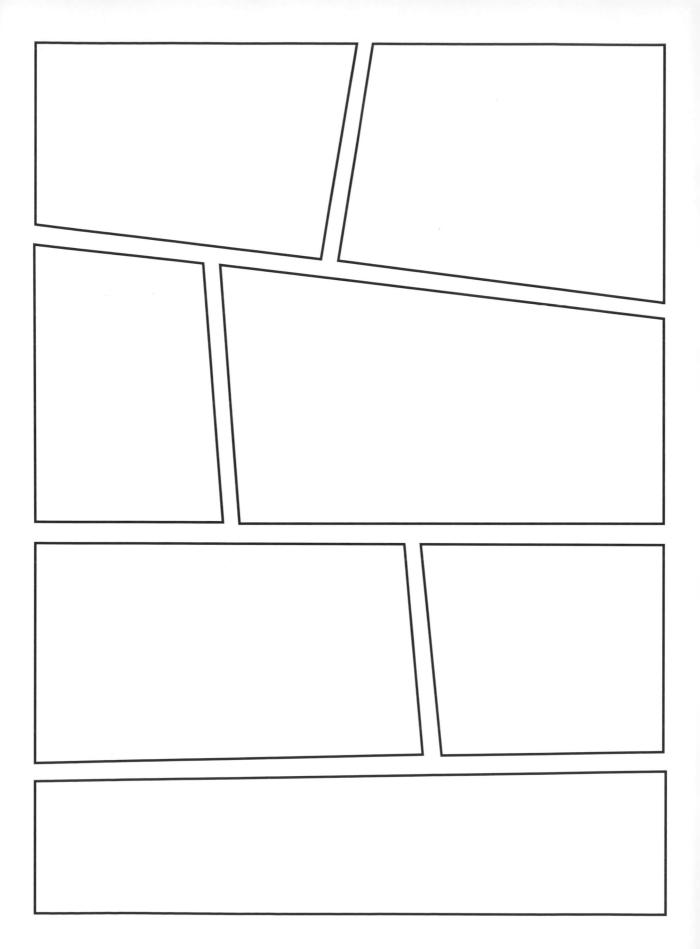

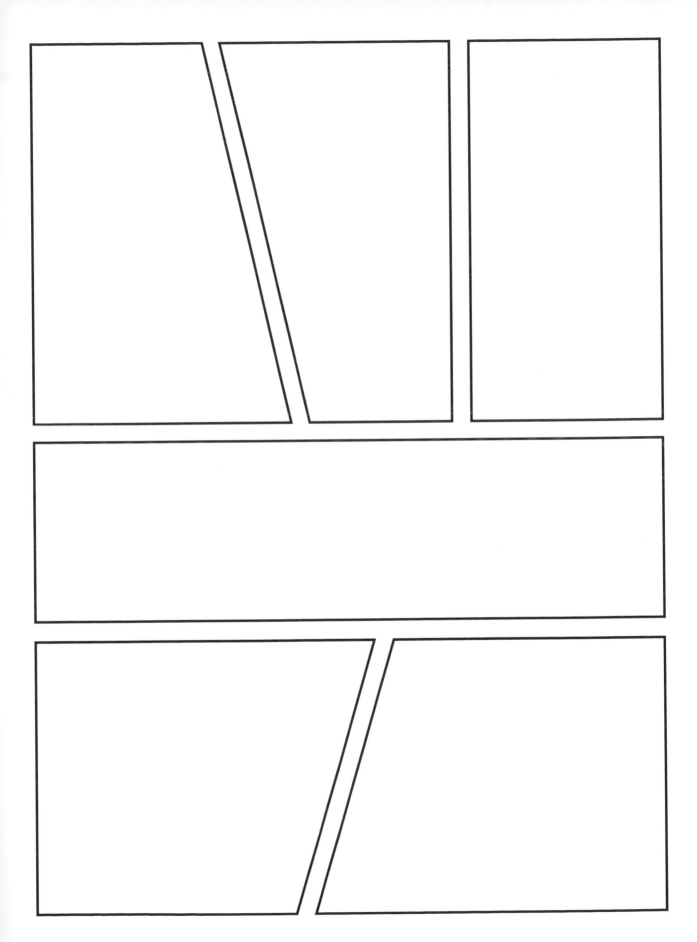

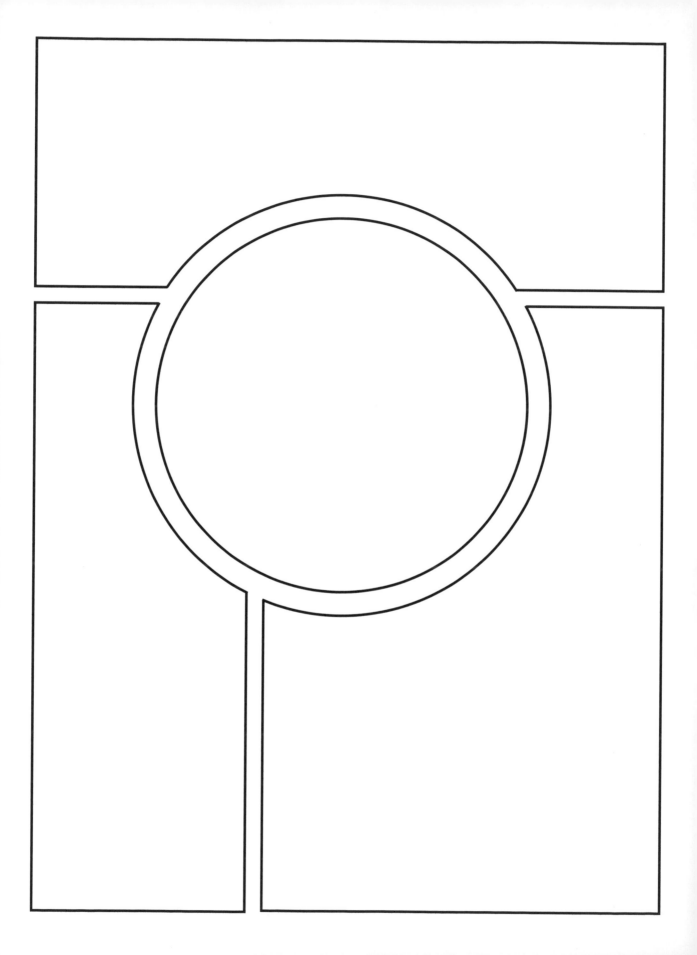

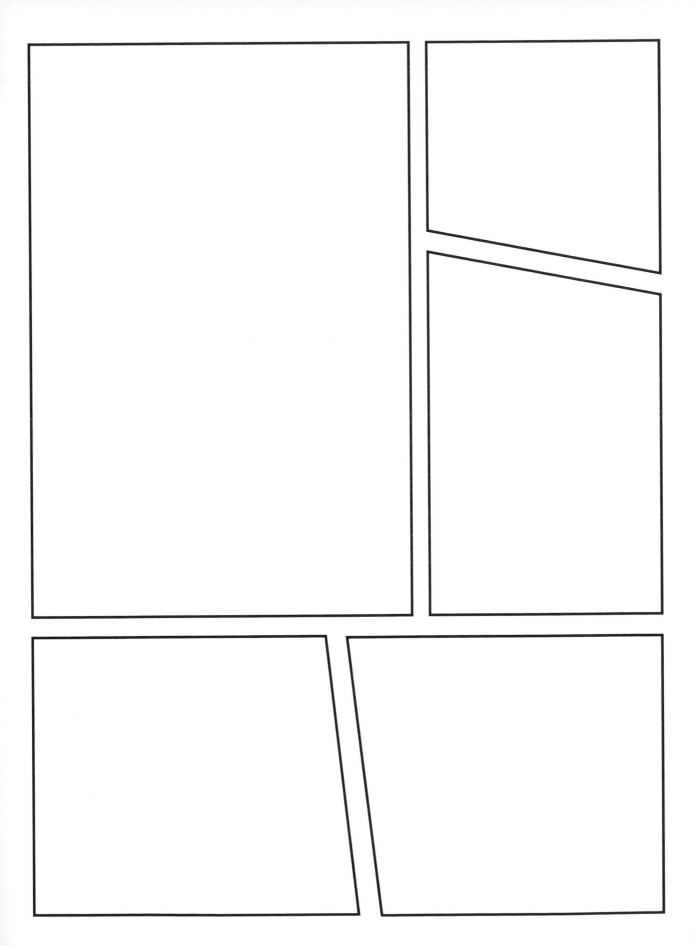

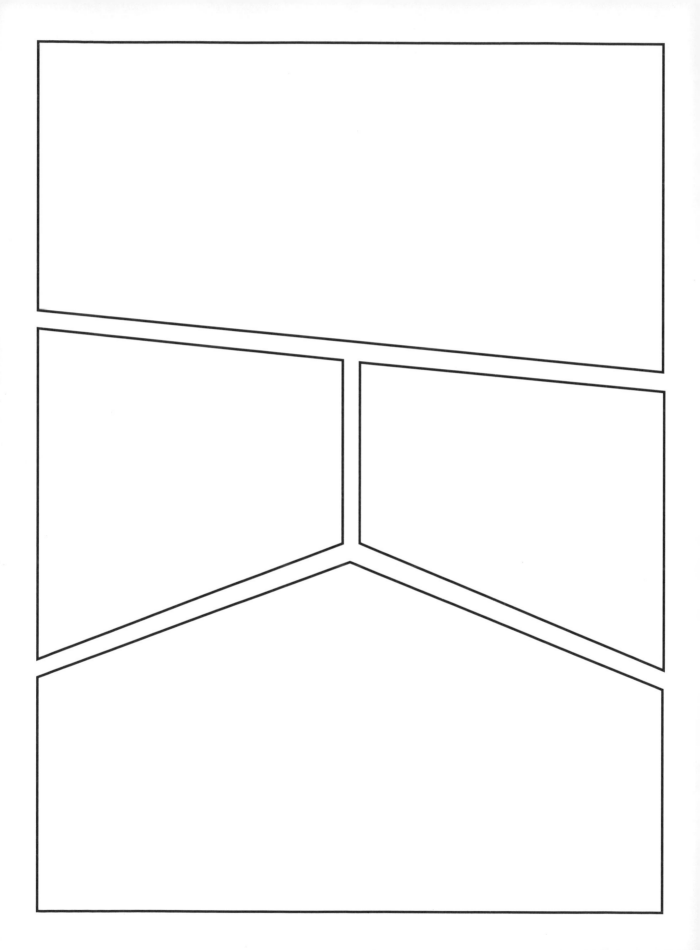

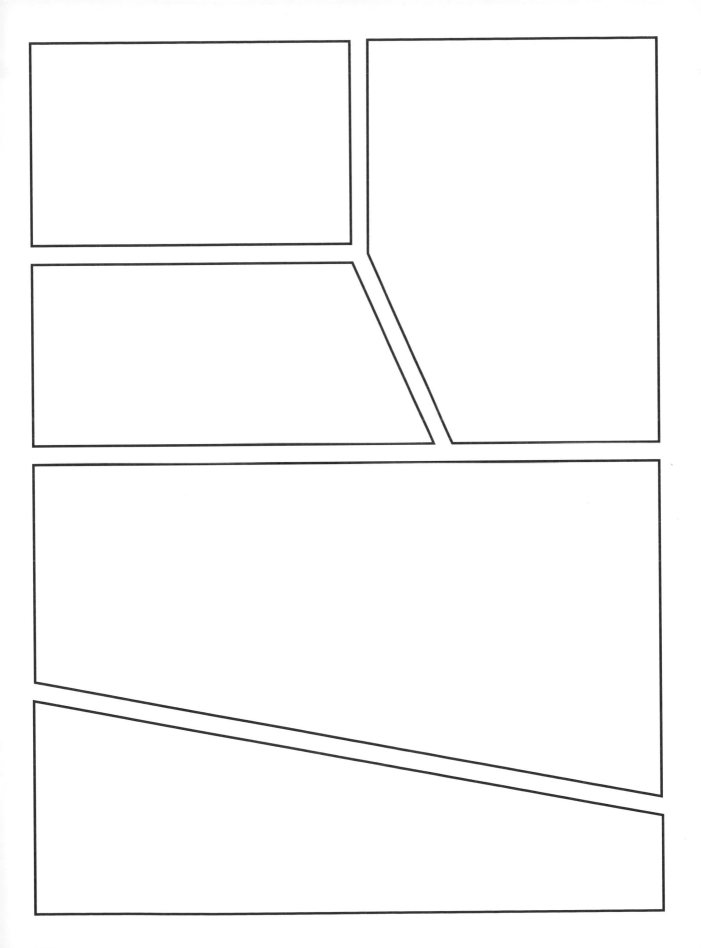

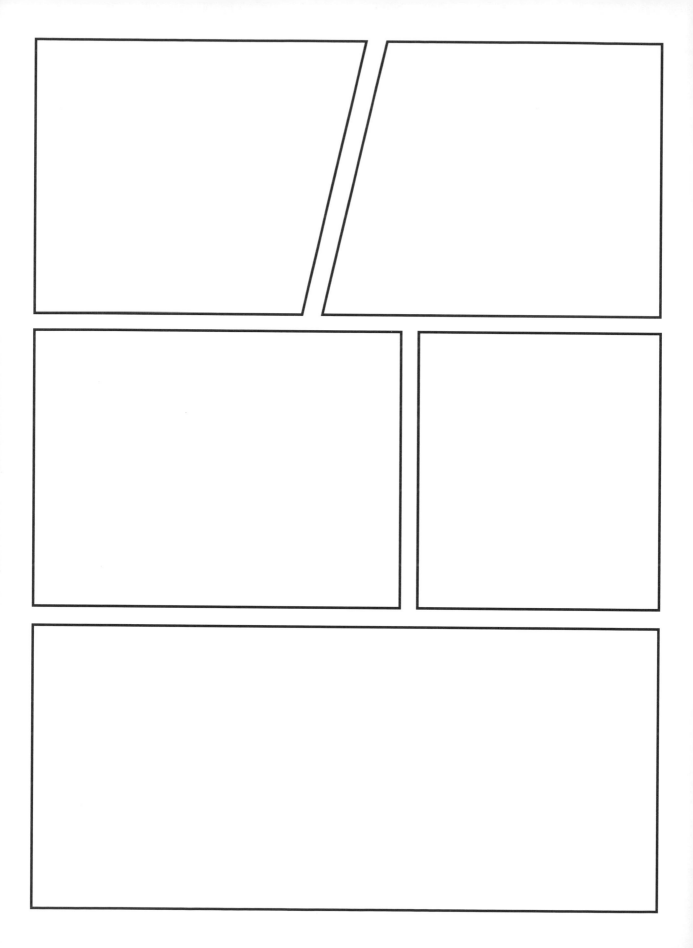

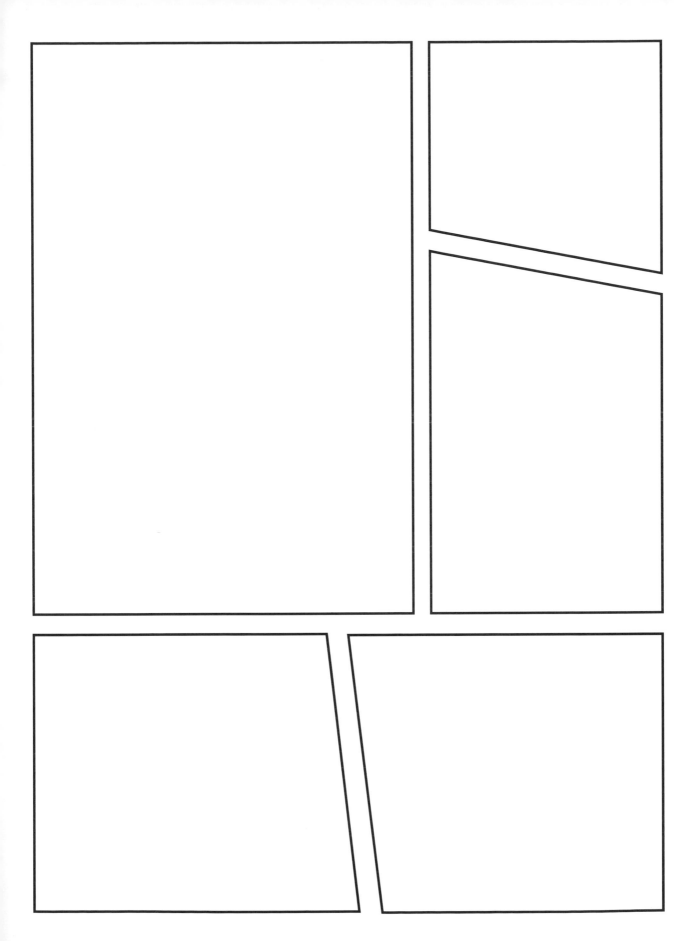

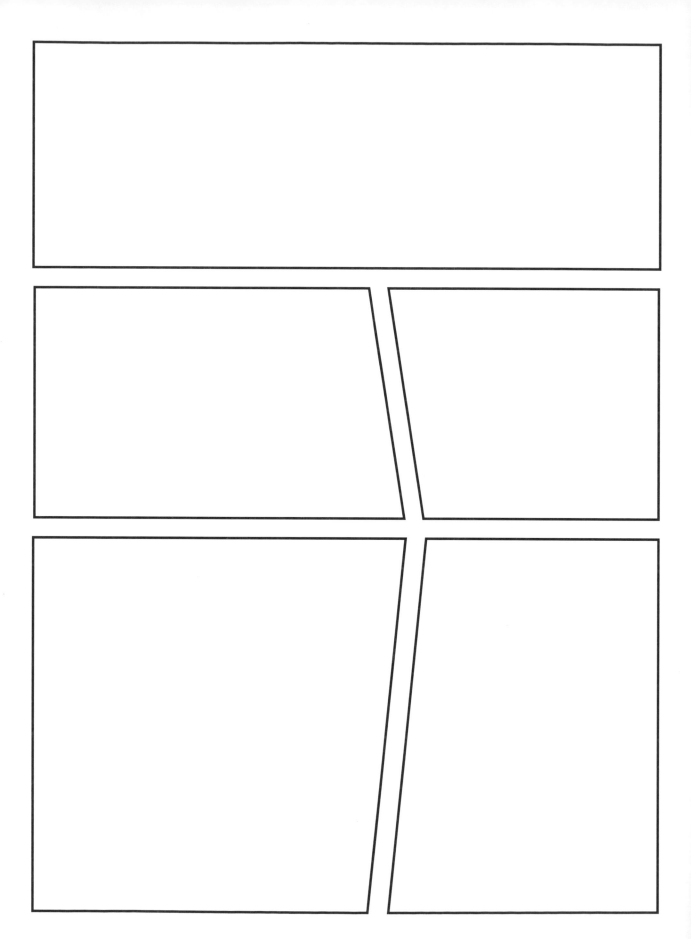

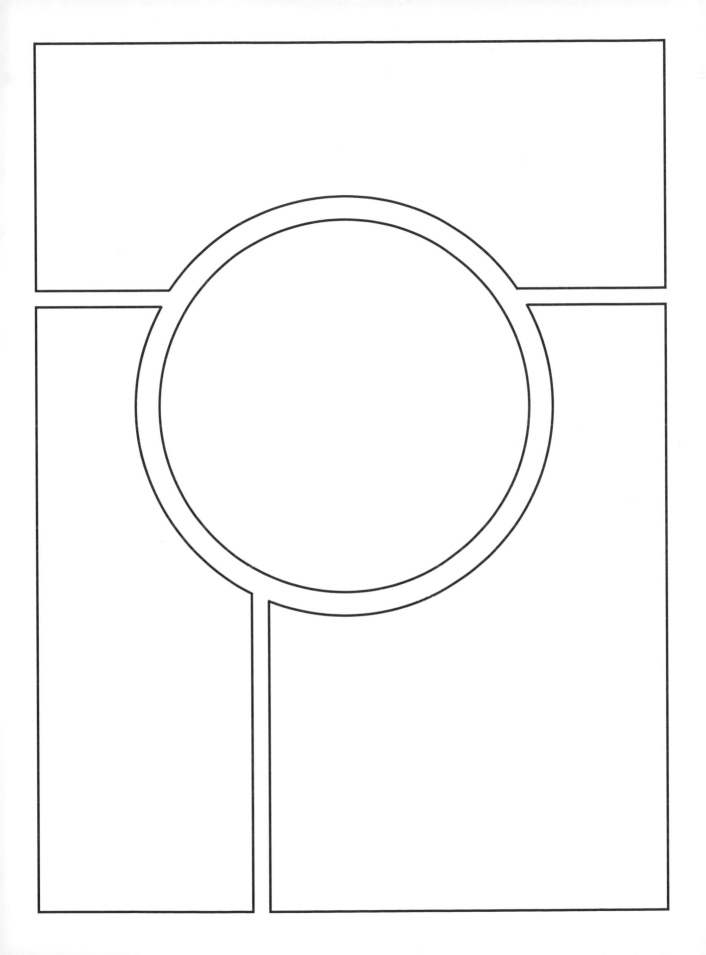

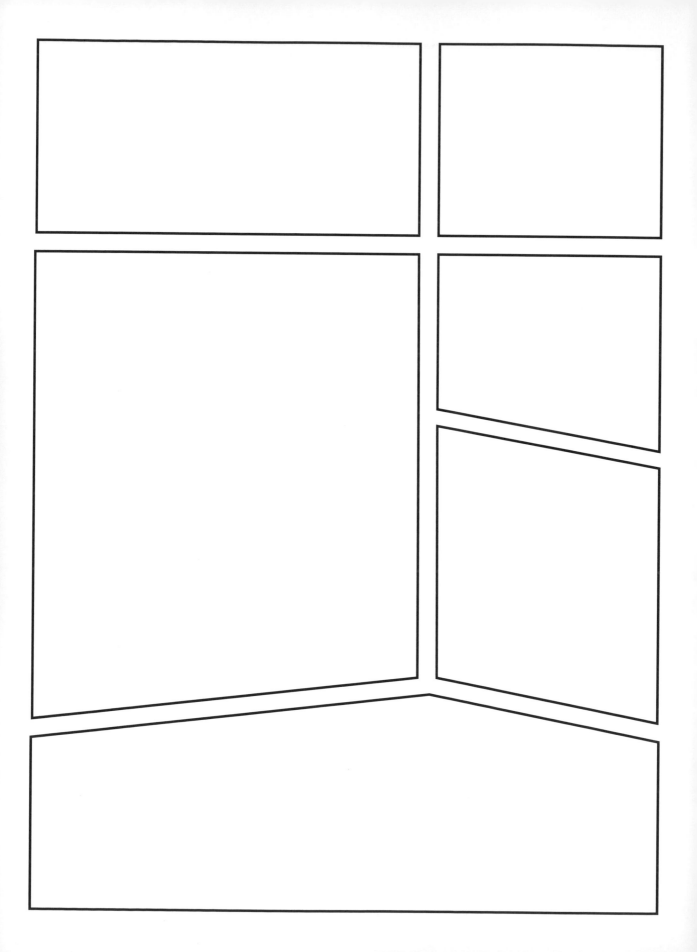

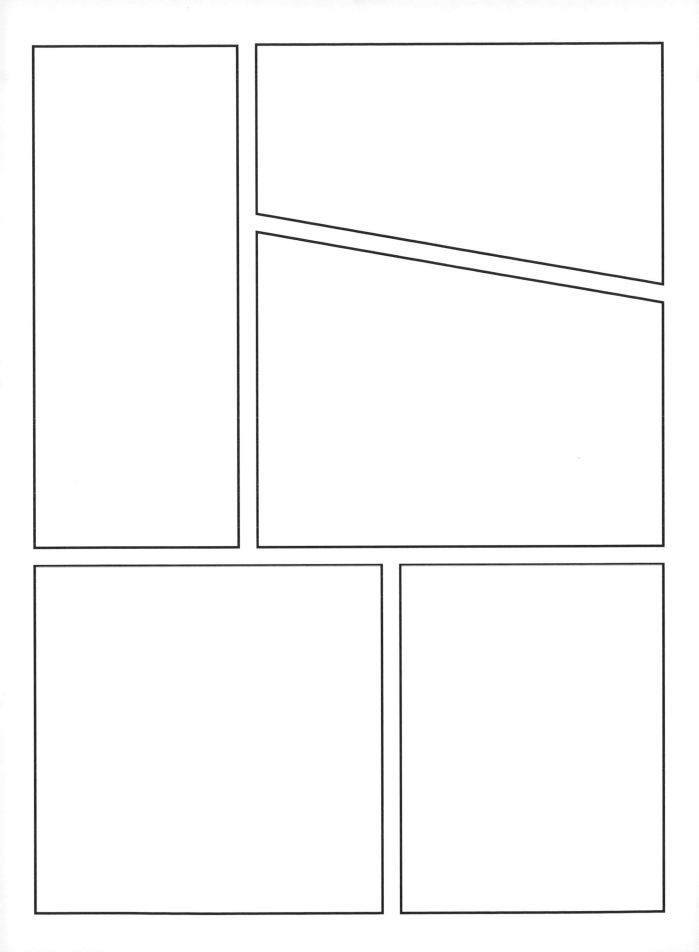

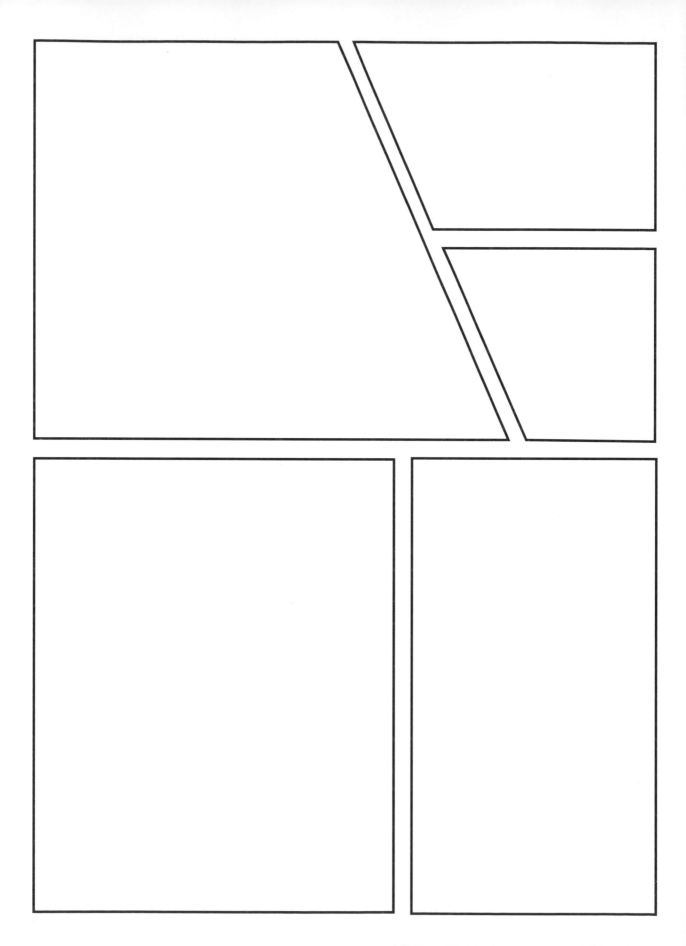

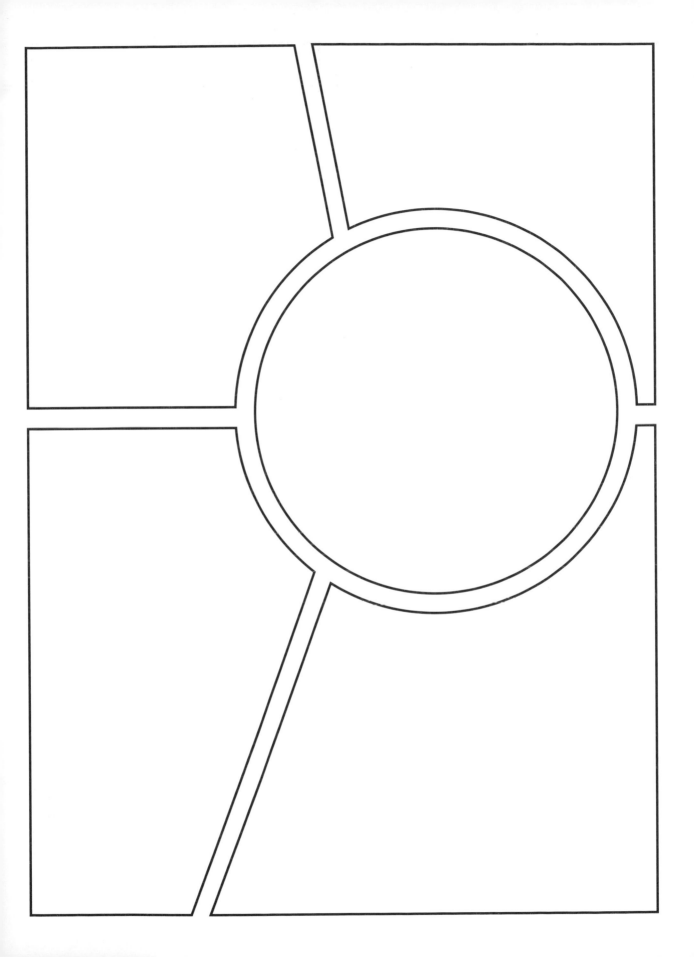

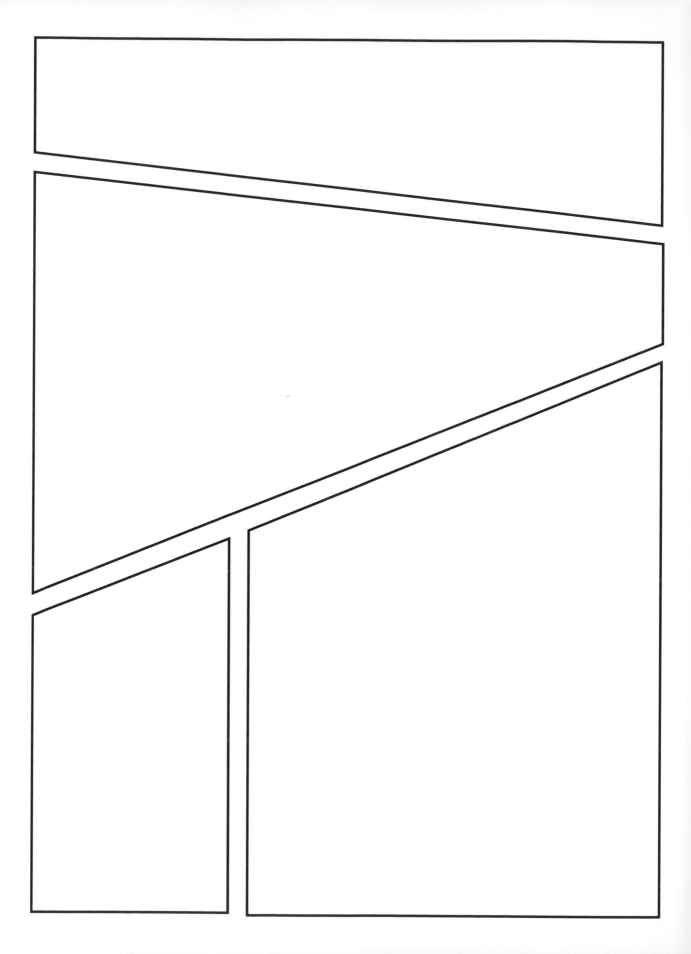

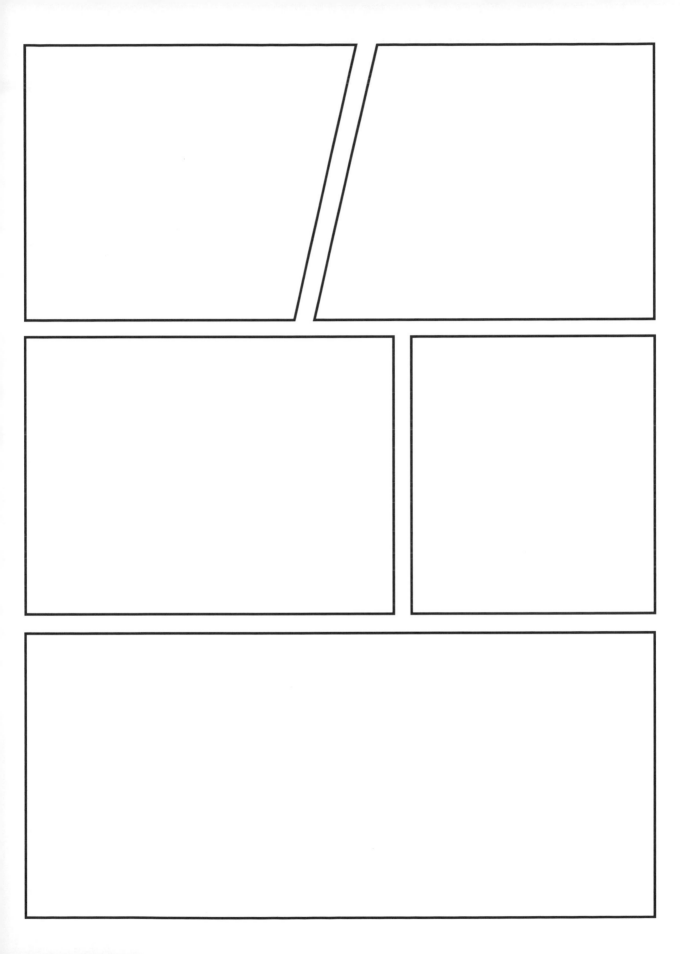

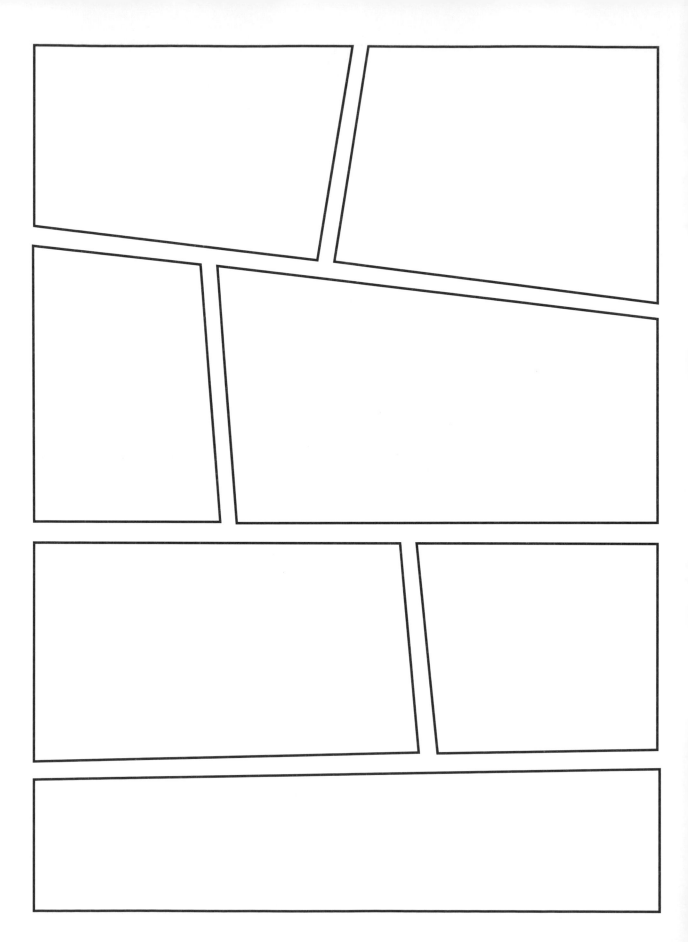

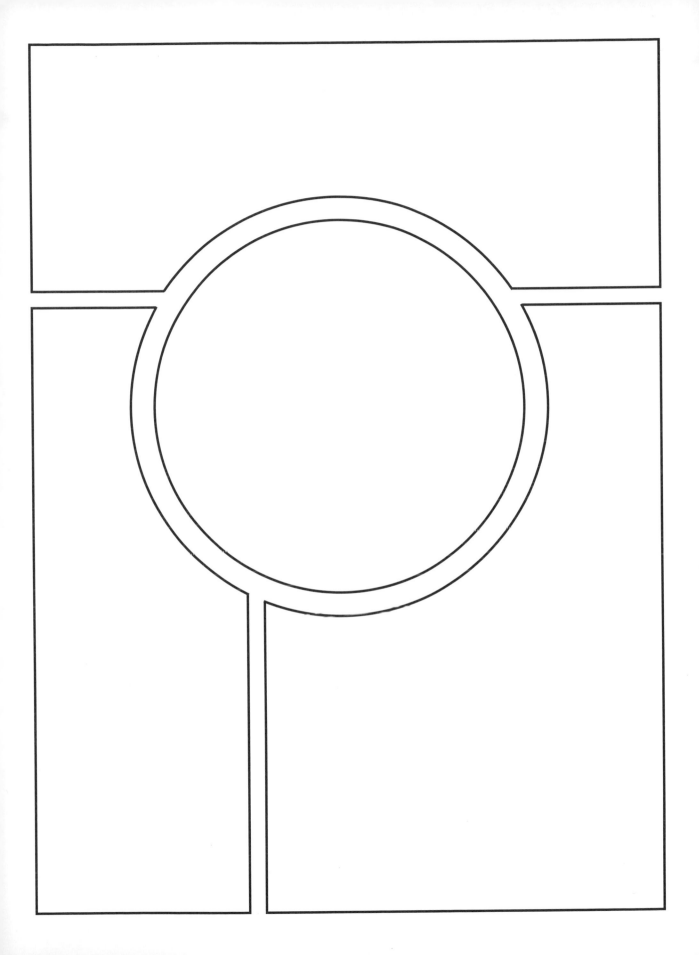

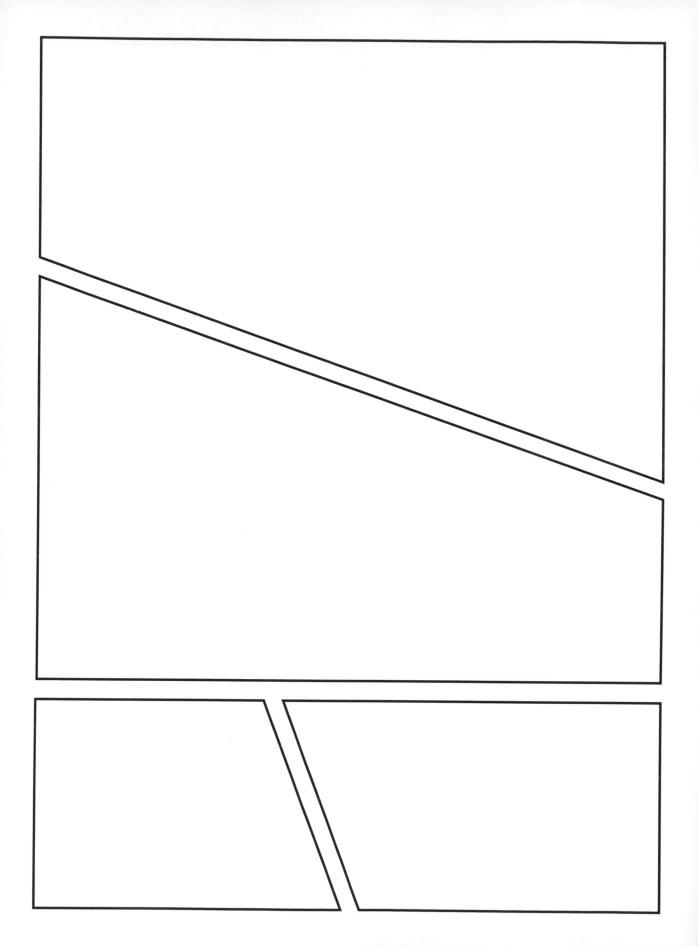

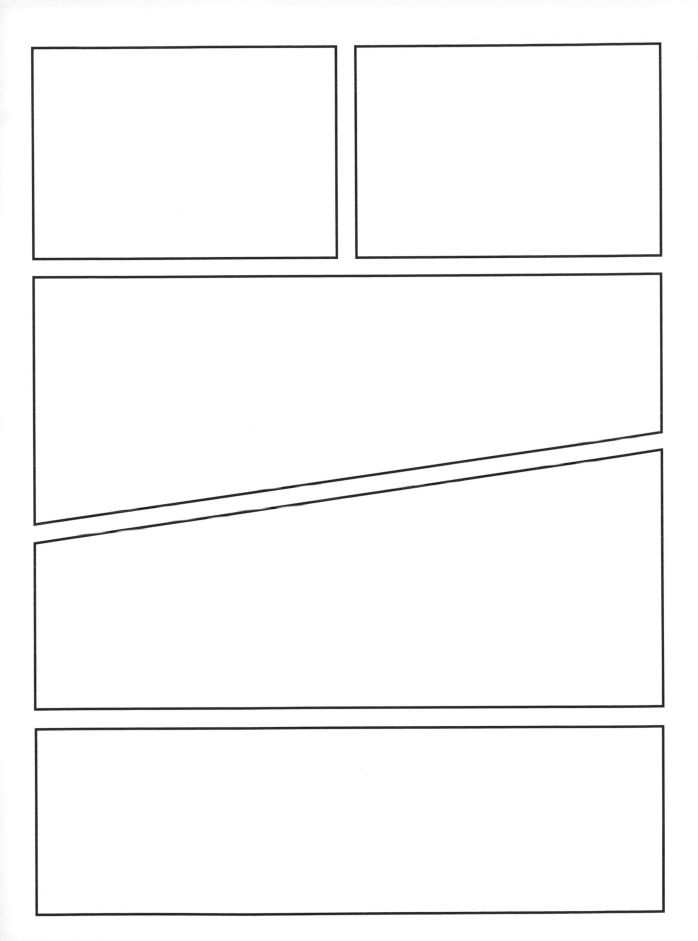

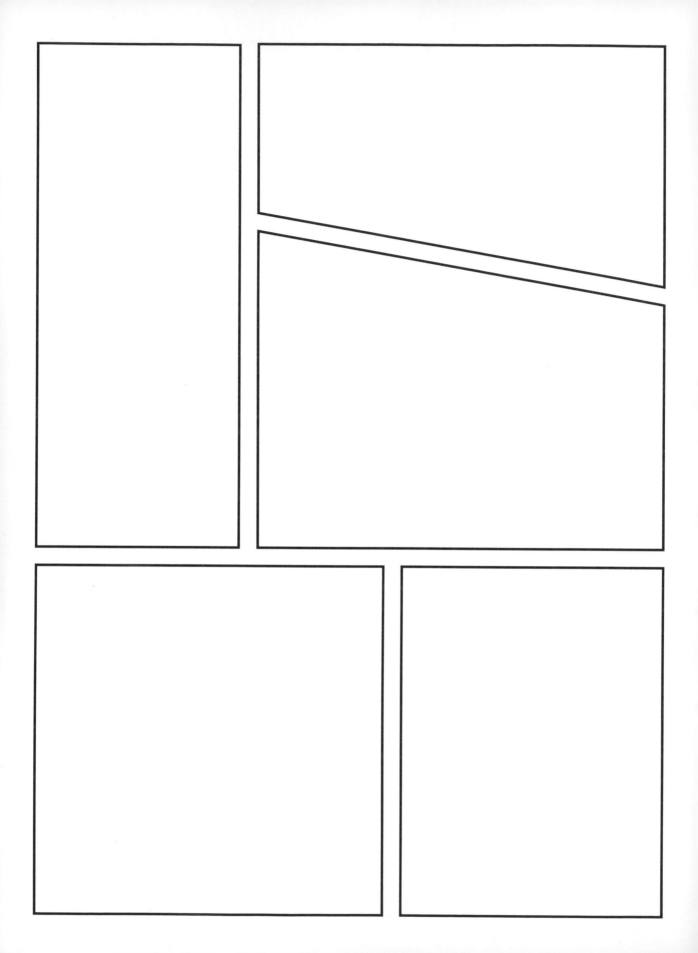

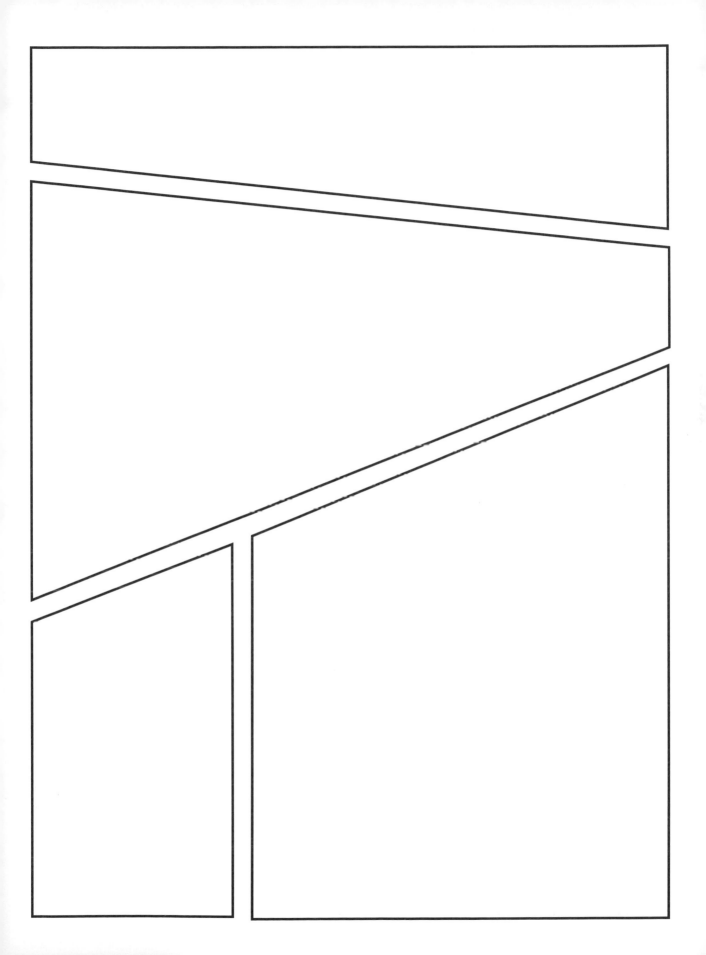

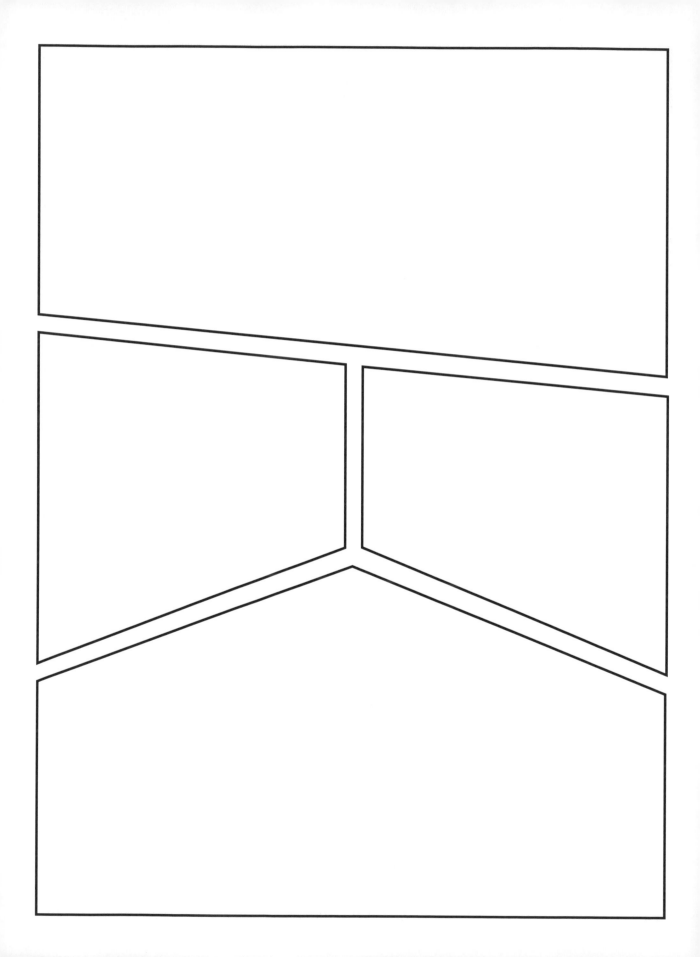

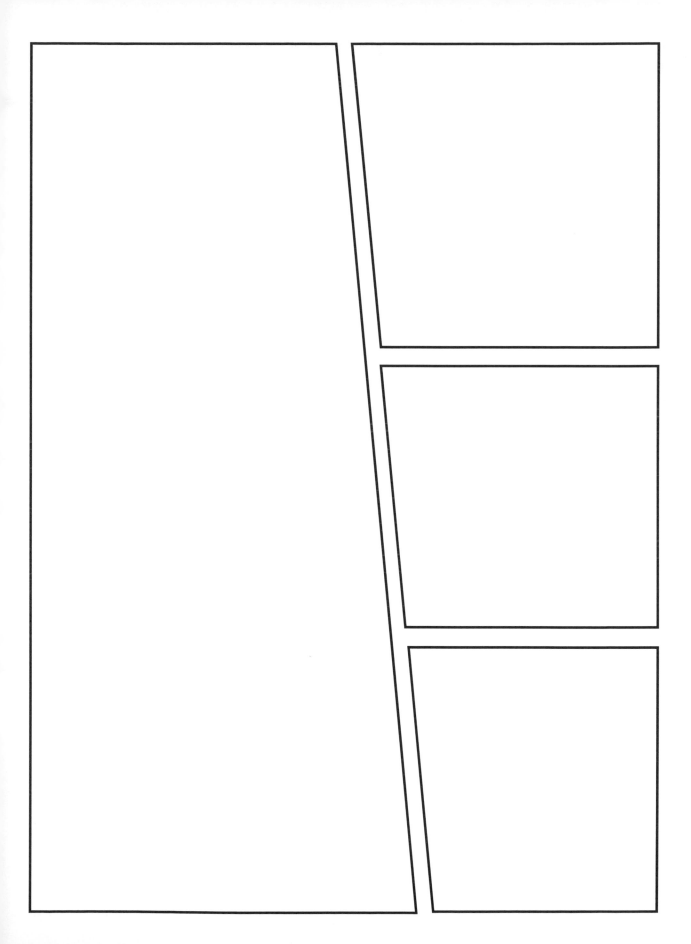

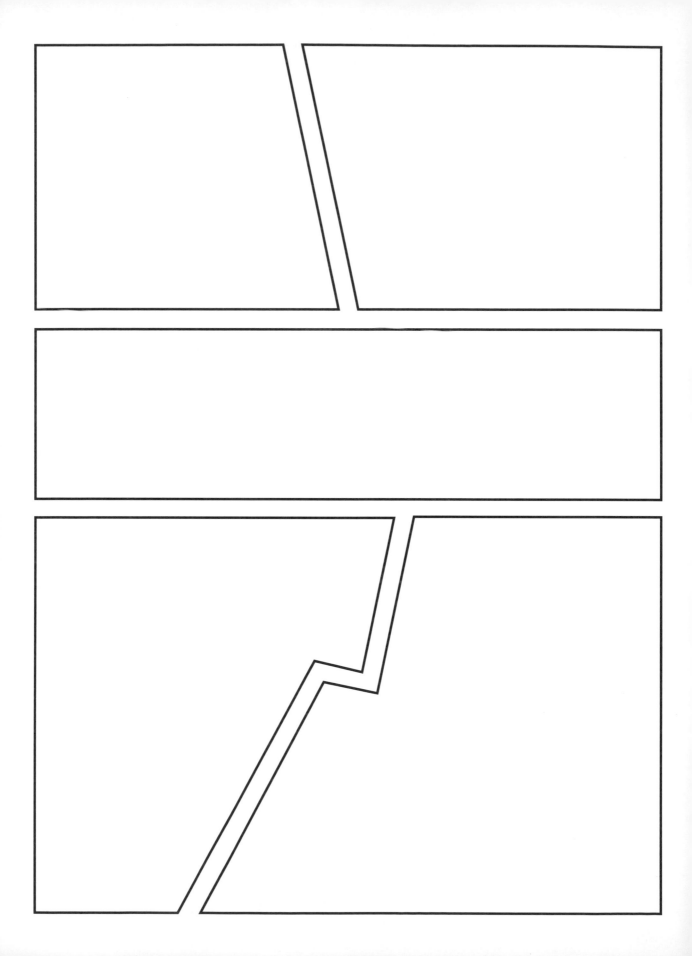